Happy

To: Ellie
From: Julie
Date: May 27, 2018

You're
Woof-derful!

PHOTOGRAPHY BY

rachaelhale

HARVEST HOUSE PUBLISHERS
EUGENE, OREGON

You're Woof-derful!

Published by Harvest House Publishers
Eugene, Oregon 97402
www.harvesthousepublishers.com

ISBN 978-0-7369-6268-1

Design and production by Dugan Design Group, Bloomington, Minnesota

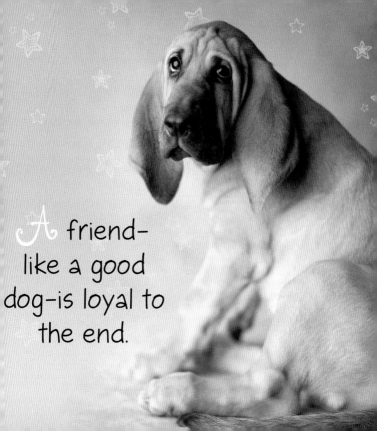

A friend–
like a good
dog–is loyal to
the end.

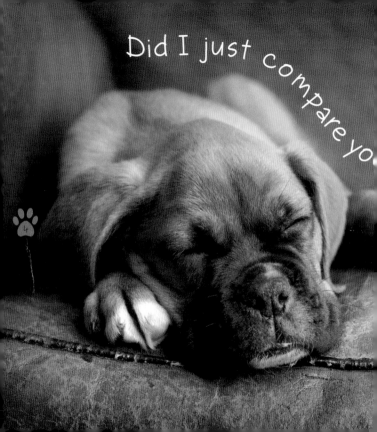

to a dog?

5

Hairstyles for dogs

Pets Unleashed

rachaelhale

I guess I did,

Friends...they cherish each
other's hopes. They are kind
to each other's dreams.

HENRY DAVID THOREAU

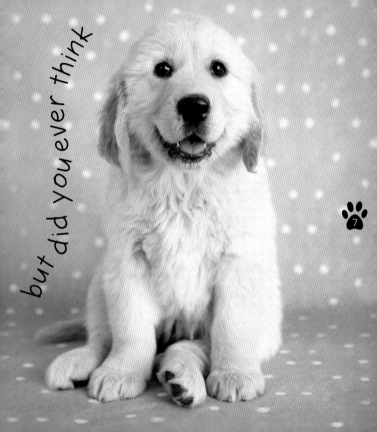

but did you ever think

how much we have in common

MY
EARLY
LIFE

WINSTON S.
CHURCHILL

HOWITT'S
RURAL LIFE
OF
ENGLAND

Cyclo
of
NewZe

Vol
Ne
Warb

Wes

With " man's best friend"?

9

We're constantly yapping

10

about this and that.

11

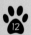

Our walk counts far more
than our talk, always!

GEORGE MULLER

Sometimes we bark at each othe

'd sometimes

we may even bite,

13

but you're the first one I call

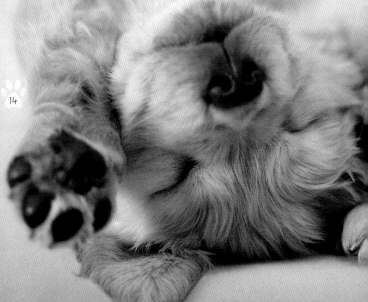

in the middle of the night.

15

We hear things

other humans don't

and go places

others won't.

Two can accomplish more than
twice as much as one, for the
results can be much better.

THE BOOK OF ECCLESIASTES

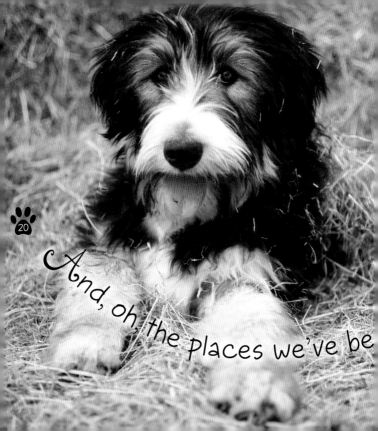

And, oh, the places we've be

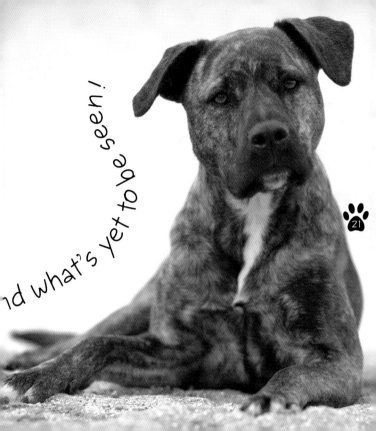

nd what's yet to be seen!

21

We've been in the doghouse

No friendship is
an accident.

O HENRY

a time or two.

24

We've shed some tears together,

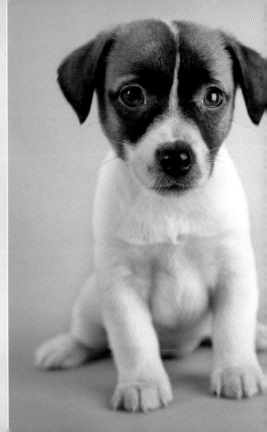

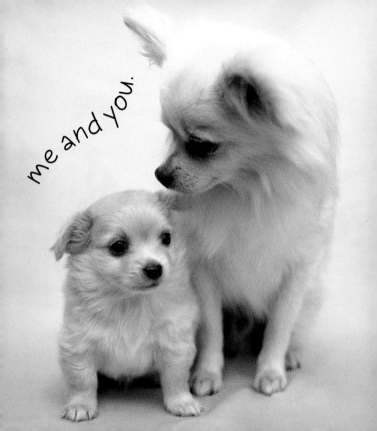
me and you.

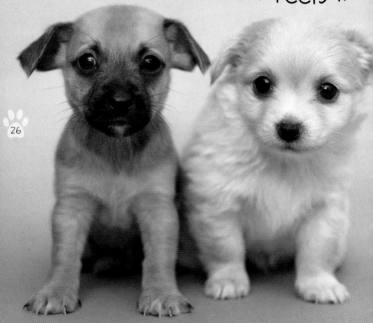

Sometimes it feels like

26

e're chasing our tails,

Yesterday brought the beginning.
Tomorrow brings the end,
but somewhere in the middle,
we've become best friends.

AUTHOR UNKNOWN

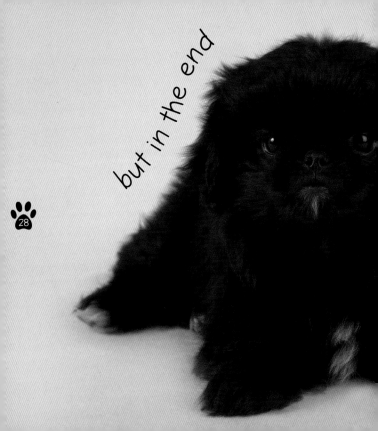

but in the end

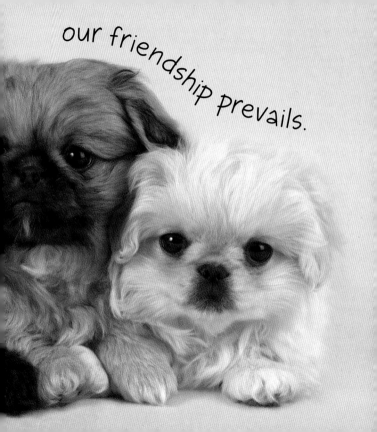
our friendship prevails.

30

We settle

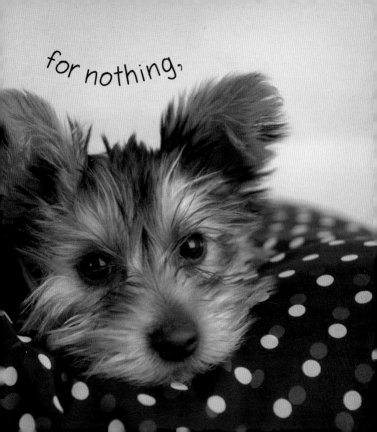

for nothing,

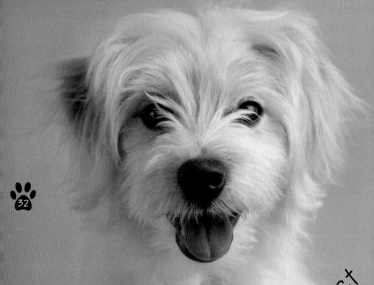

32

and expect

nothing less.

To accomplish great things, we
must not only act, but also dream;
not only plan, but also believe.

ANATOLE FRANCE

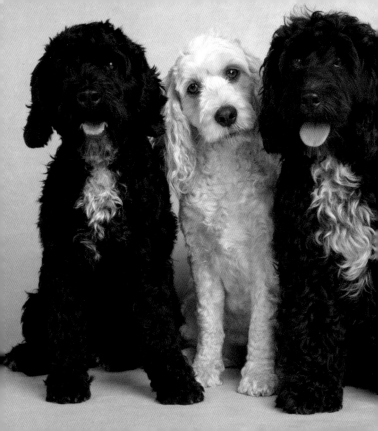

We question
EVERYTHING!

Where

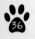

Where does the light come from,
and how do you get there? Or tell me
about the darkness. Where does
it come from? Can you find its
boundaries, or go to its source?

THE BOOK OF JOB

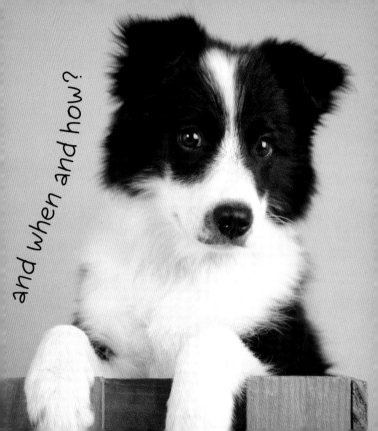

and when and how?

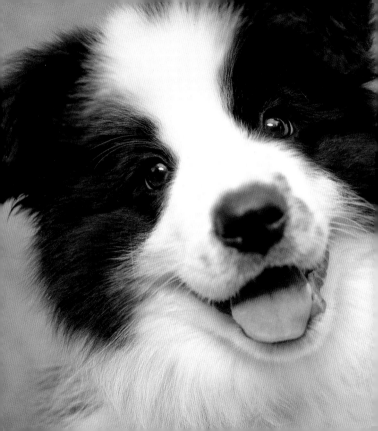

What's to come
and why not now?

No worries!

Happiness consists in
being perfectly satisfied with
what we have got and what we
haven't got.

CHARLES H. SPURGEON

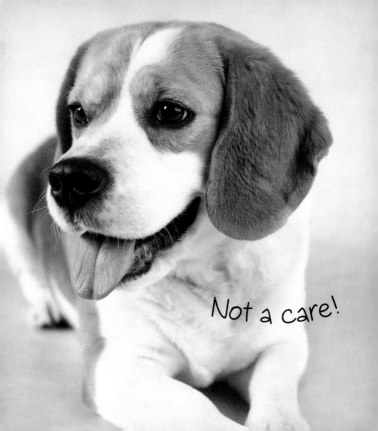

Not a care!

42

You believe in me.

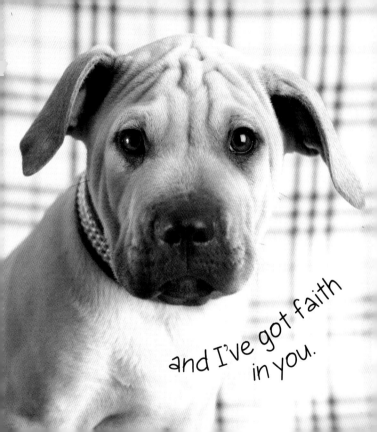

and I've got faith
in you.

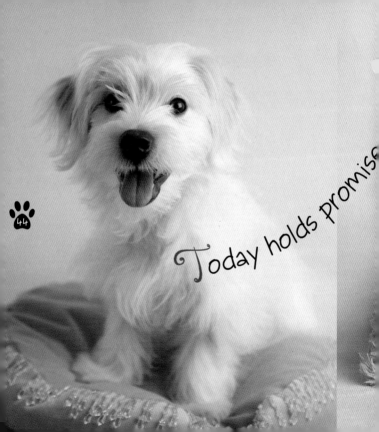

Today holds promise

and tomorrow does too.

When friends walk together,

46

the walk is good.

A joy shared is a joy doubled.
JOHANN WOLFGANG VON GOETHE

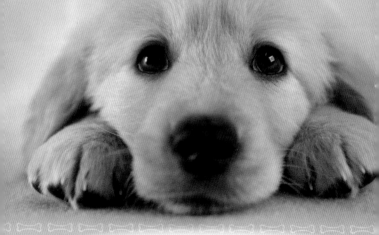

The journey's even better.

A true friend is always loyal...
THE BOOK OF PSALMS